# DRAWbreakers

## A Drawing Book That We Start and You Finish

by the editors of Klutz and **YOU**

**KLUTZ**®

# KLUTZ

is a kids' company staffed entirely by real human beings. We began our corporate life in 1977 in an office we shared with a Chevrolet Impala. Today we've outgrown our founding garage, but Palo Alto, California, remains Klutz galactic headquarters. For those of you who collect corporate mission statements, here's ours:

- Create wonderful things.
- Be good.
- Have fun.

### Write Us.

We love to hear from our readers. Send us your glowing comments or a photocopy of your best Drawbreaker. We always write back. Use a stamp, e-mail, or try mental telepathy. (Hey! You never know.)

**Visit Us:**  KLUTZ.com

**KLUTZ** ®
455 Portage Avenue
Palo Alto, CA 94306

Book manufactured in U.S.A.

4 1 5 8 5 7 0 8 8 8

### Want More Klutz Books?

For the location of your nearest Klutz retailer, call (650) 857-0888. Should they be tragically out of stock, additional copies of this book, and the entire library of 100% Klutz certified books are available in our mail order catalog. See back page.

### Do You Teach?

We offer a classroom set of make-your-own Klutz books. E-mail bookfactory@klutz.com, write, or visit our website for details.

Klutz is a Nelvana company

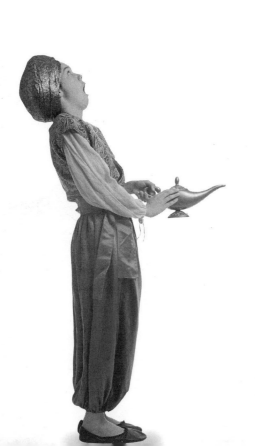

# What Are Drawbreakers?

THEY'RE HALF-DONE PICTURES JUST DYING TO BE DONE. ALL THEY NEED IS SOME FABULOUS GENIUS TO STEP ONTO THE PAGE AND FINISH THE JOB.

THAT'S WHERE YOU COME IN. BRING PENCIL, PEN, CRAYONS, COLORED PENCILS OR COLOR MARKERS. ANYTHING WORKS. NO DRAWBREAKER HAS EVER BEEN DONE WRONG AND EACH OF THEM CAN BE FINISHED IN MORE THAN 4,800,102 WAYS (ALL RIGHT).

AND WHEN YOU'RE DONE, WRITE US! WE LOVE MAIL, EITHER E- OR OTHERWISE. SEND US A PHOTOCOPY OF YOUR FAVORITE FINISHED DRAWBREAKER AND IF WE LOVE IT, WE'LL PRINT IT IN THE NEXT EDITION OF THIS BOOK. (WE'VE SAVED A PAGE IN THE BACK FOR ALL OF OUR MAILED-IN FAVORITES. LOOK AT IT FOR OUR ADDRESSES AND ALL.)

HELP! I NEED FINISHING!

Strange, alien plants growing in a garden.

Strange plants get hungry.

Strange plants eat gardener.

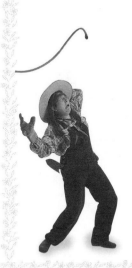

# PINOCCHIO'S NOSE...

...after 2 lies

...after 10 lies

...after 50 lies

...after 1,000 lies

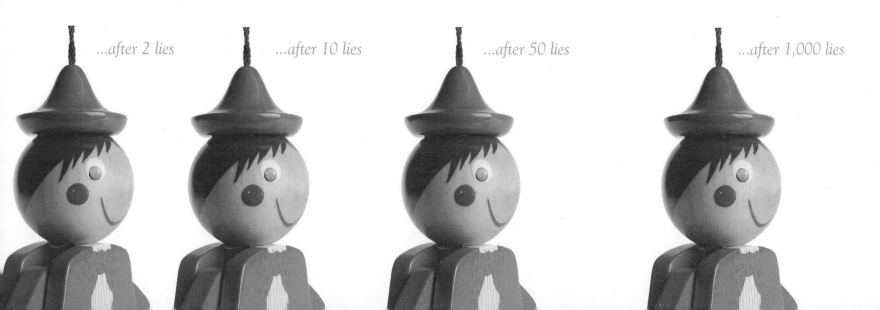

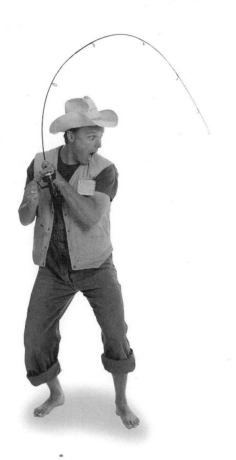

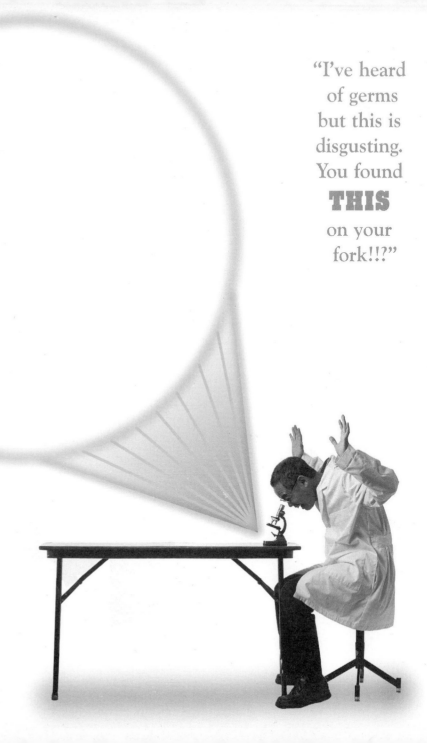

"I've heard of germs but this is disgusting. You found **THIS** on your fork!!?"

## IN BIZARRE FISHING INCIDENT, MAN CATCHES...

- boot
- Loch Mess monster
- kitchen sink
- great white shark
- octopus
- 60-pound minnow
- aqua-cat
- giant bug-eyed bass
- treasure chest
- submarine
- mermaid...

*Winter.* No leaves. Time to build a snowman with a carrot for a nose.

*Summer.* Tire swing and me.

*Spring.* Just hanging around.

*Fall.* Big pile of leaves.

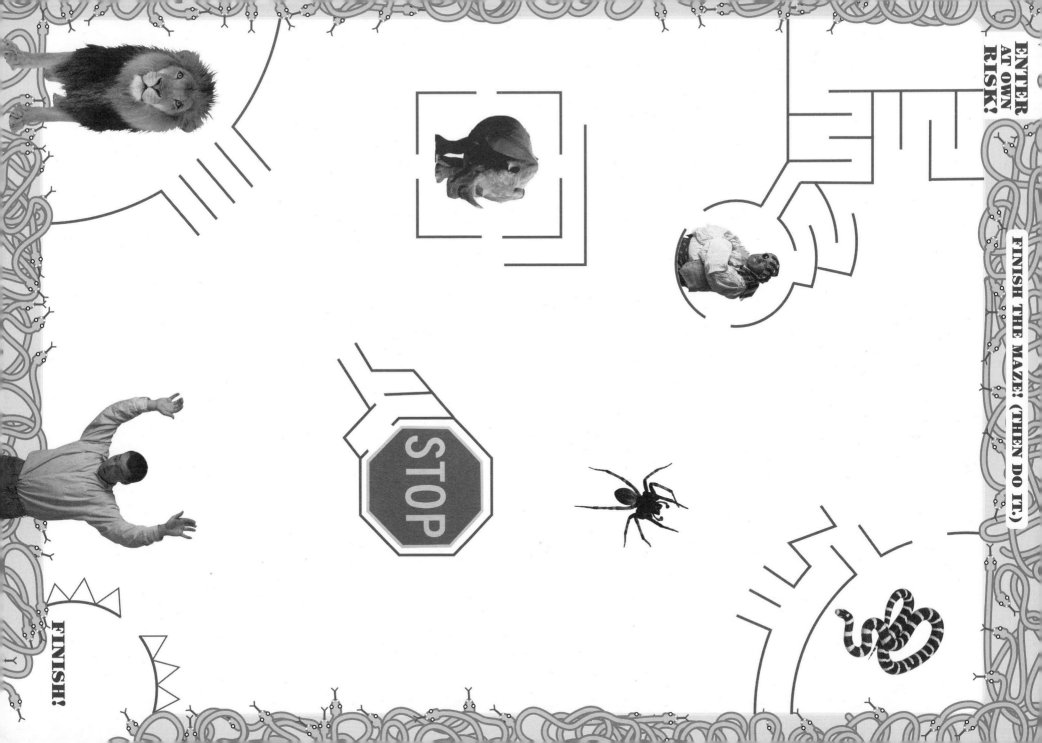

FINISH THE MAZE! ('THEN DO IT.)

STOP

FINISH!

# LOOK! UP IN THE SKY!

ADD SKY, EVIL FLYING MONKEYS, CLOUDS, ALIEN SPACESHIPS, BIRDS, KITES, BUNGEE CORD, PARACHUTE, FLYING TOASTERS, BROOM, ANGEL WINGS AND HALO, HELICOPTER...

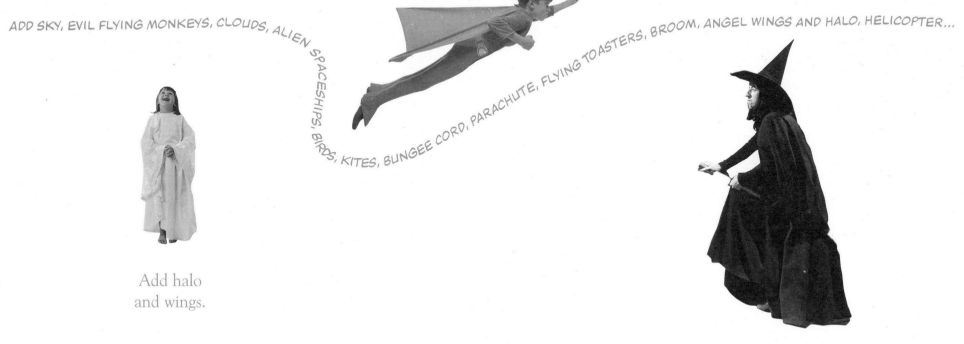

Add halo
and wings.

Add broom.

Add bungee cord.

Add stork.

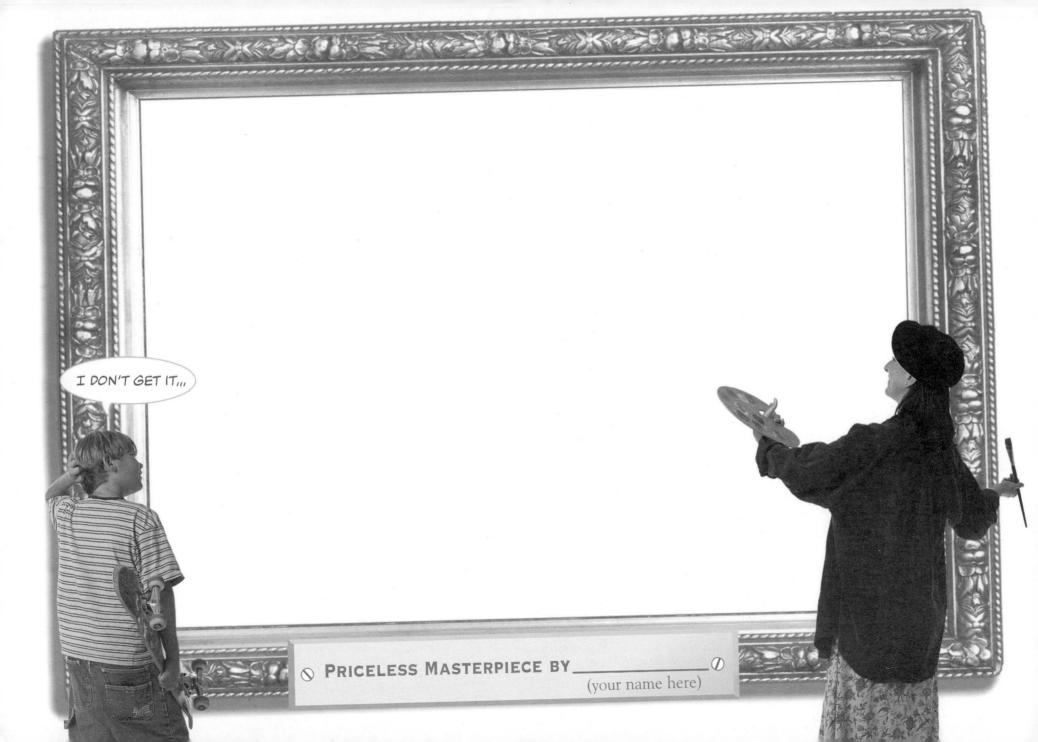

# EXTRA!

## Mayor Declares Bio-Emergency

### The Oddburgh Gazette

# Fourteen-Ton Tomato Garnishes Downtown

## Fears of Genetic Meddling Realized

ODDBURGH, Tennessee—According to Mayor J. Harmon Puree, the first signs of trouble came just after noon when an alarm sounded at Mel's Mondo Fruit Farm just north of town. Minutes later, the Shady Deal Trailer Park was flattened by a rapidly rolling object that was later identified as a tomato. City Director of Fruit and Vegetable Control. Dr. Constance Le Gume, confirmed that the tomato "certainly exceeded 'normal' size." Under pressure from reporters, Le Gume admitted that the rampaging fruit "probably exceeded fourteen tons." After the obligatory trailer damage, the rogue

**Tragic Victim "My Best Dress"**

tomato picked up considerable speed as it careened over two mini-malls and a drive-thru massage parlor. By the time it entered downtown Oddburgh, the huge beefsteak had reached what Dr. Le Gume described as "T.T.V." (terminal tomato velocity) and had begun to leak a slimy spray of tomato juice and football-sized seeds. The Oddsburgh police cruiser was in hot pursuit at this point, but was unable to ketch up. The impact with City Hall was described by horrified witnesses as "ugly." Cleanup of the eight-block metro area is expected to take several weeks. Mel, of Mel's Mondo Fruit, termed the incident "an isolated inventory control problem." Residents have pressed for an investigation prior to the upcoming watermelon season.

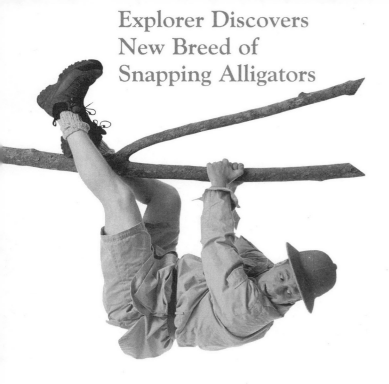

Explorer Discovers
New Breed of
Snapping Alligators

Man Proves
Existence of
Big Foot

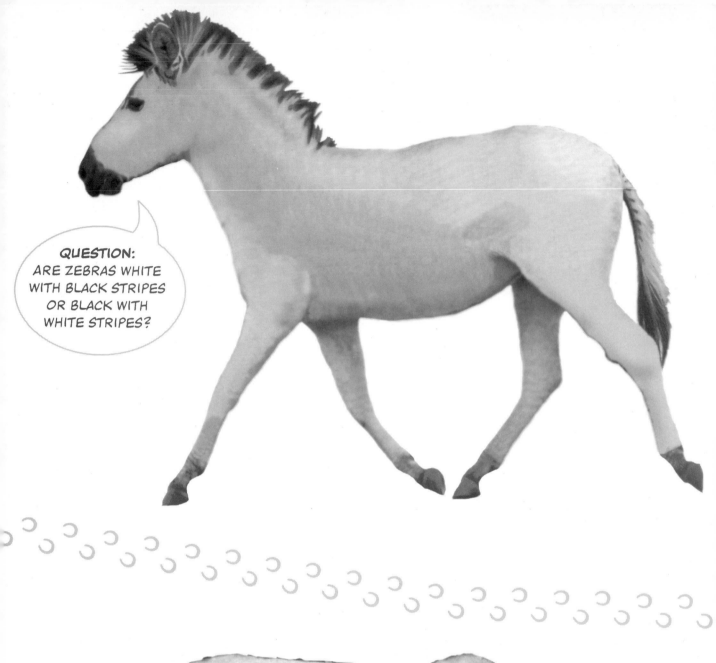

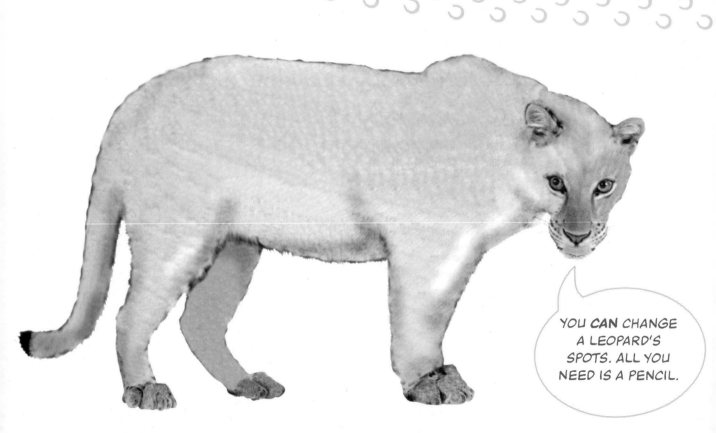

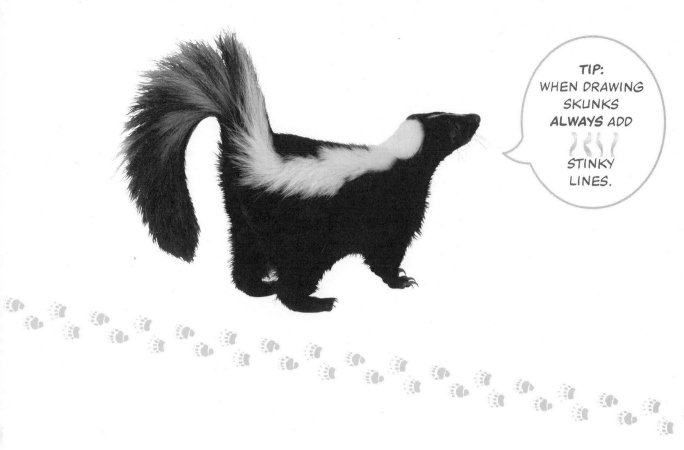

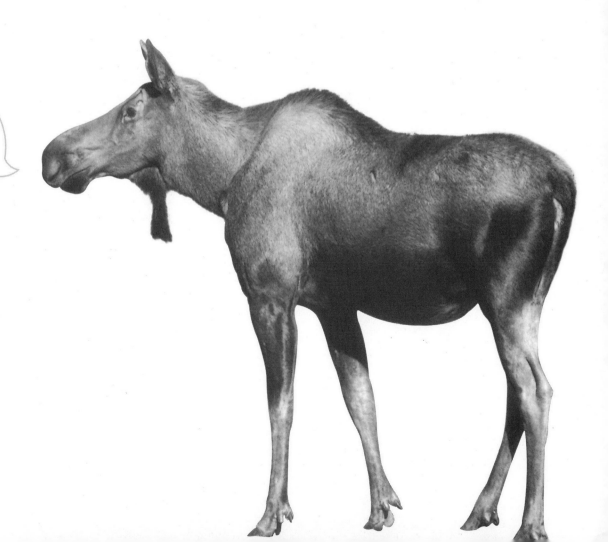

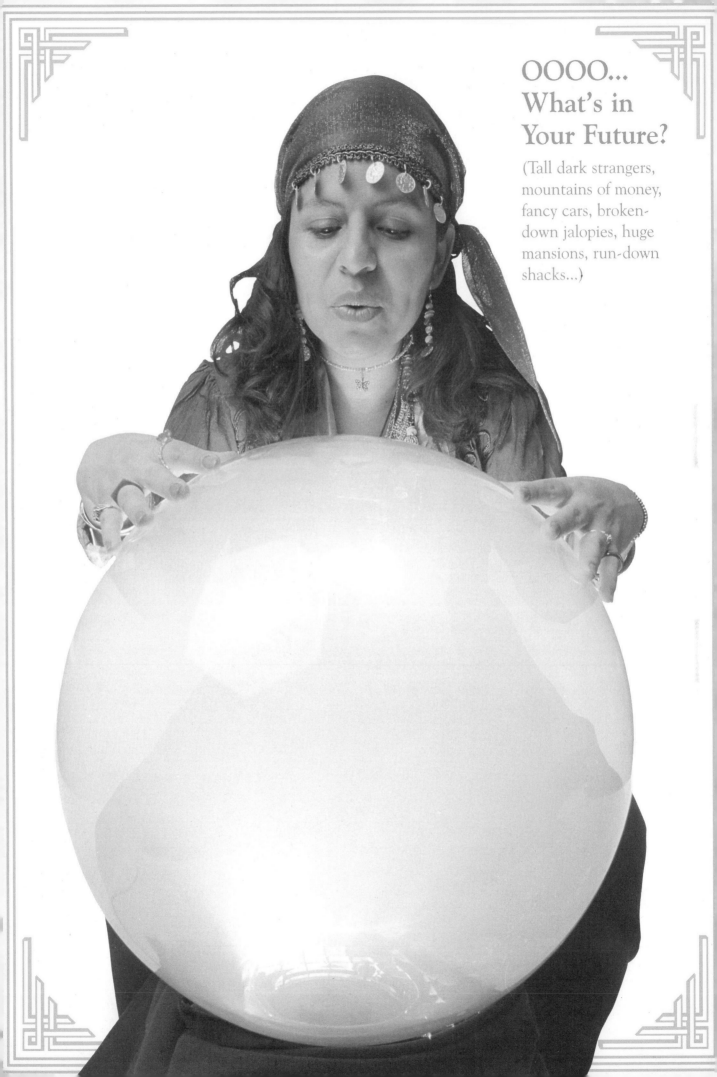

OOOO...
What's in
Your Future?

(Tall dark strangers,
mountains of money,
fancy cars, broken-
down jalopies, huge
mansions, run-down
shacks...)

# Prince Charming Climbs Rapunzel's Hair in Painful Rescue Attempt

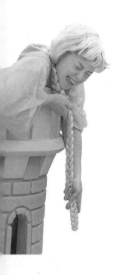

*Draw the tower, hair and prince.*

# Angry Giant Climbs Down Beanstalk

*Jack readies final chop.*

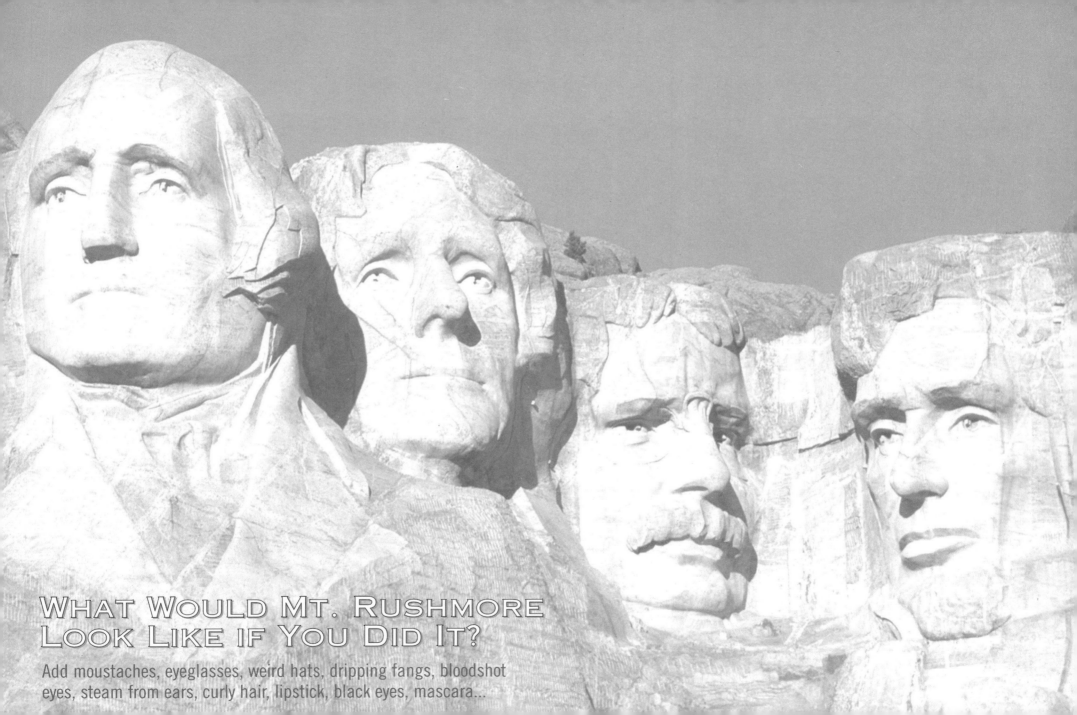

# WHAT WOULD MT. RUSHMORE LOOK LIKE IF YOU DID IT?

Add moustaches, eyeglasses, weird hats, dripping fangs, bloodshot eyes, steam from ears, curly hair, lipstick, black eyes, mascara...

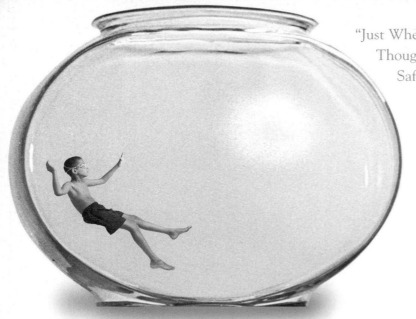

"Just When You Thought It Was Safe to Go Back in the Bowl"

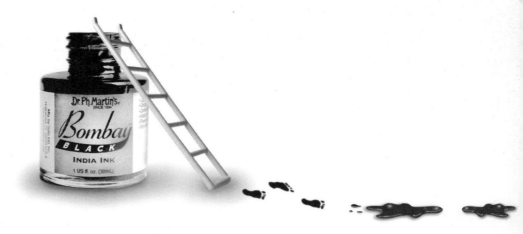

Meet the Man-Eating Goldfish

Land O'
**GIANTS**

Skinny-Dipping Down at the Old Inkwell (*Add kids.*)

Tiny Secretary Takes Notes (*Add notes.*)

Tiny Campers Warm Their Hands (*Add candles.*)

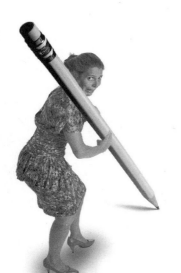

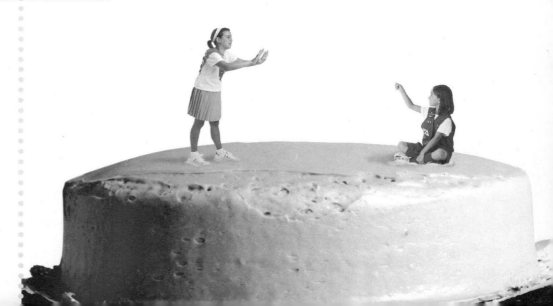

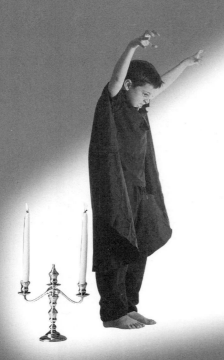

**The Shadow Page**

Draw the shadow on the wall.

# Princess Kisses Magic Frog!

## *But in Weird Mix-Up, Prince Turns Out to Be...*

(...ugliest man on Earth; short, chubby penguin; large
frog; small friendly gorilla; troll with a bad haircut...)

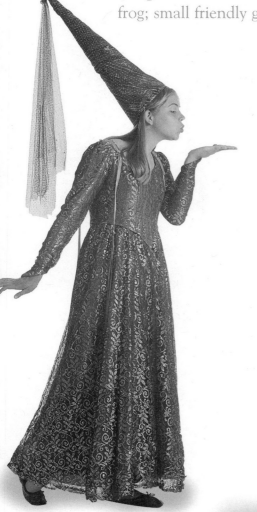

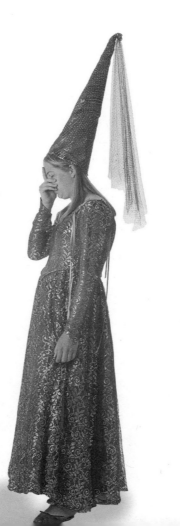

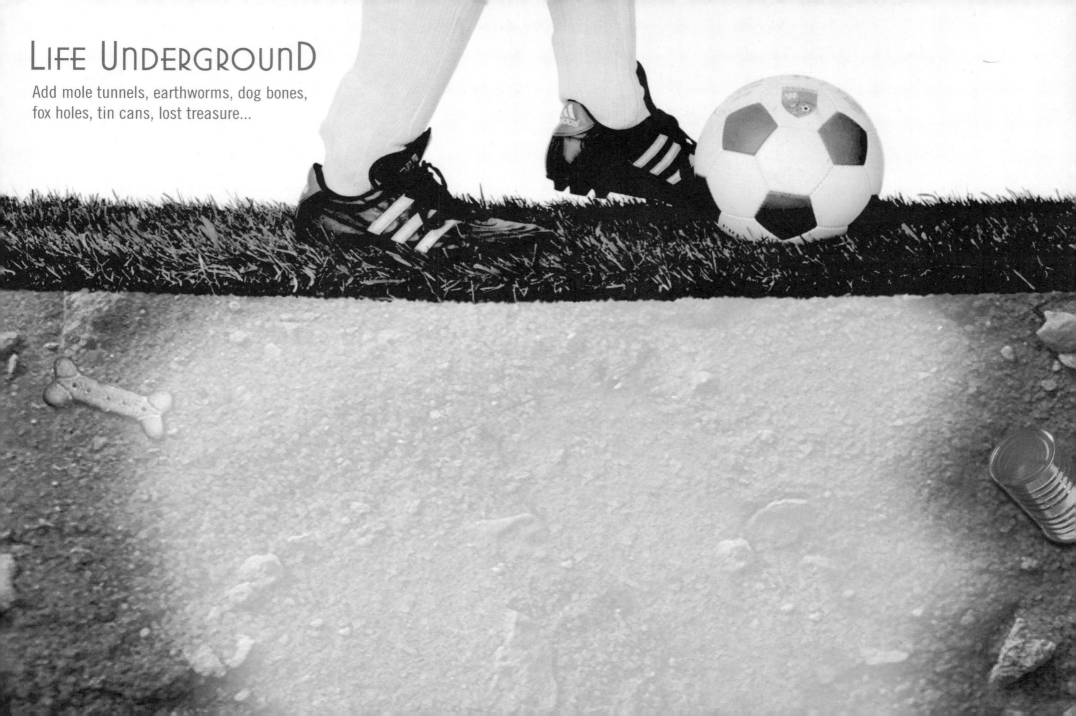

# LIFE UNDERGROUND

Add mole tunnels, earthworms, dog bones,
fox holes, tin cans, lost treasure...

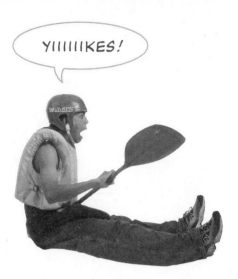

**Add Kayak.**

Add waterfall.

# Portrait of a Stalled _____ (Donkey, truck, drawer, dog, sofa, polar bear, bus...)

# The Friendly Wake-Up Throw (Add pie, wedding cake, pizza, ice cream sundae, giant mudball...)

It's Raining!

(Add umbrella and rain.)

Be My Valentine

WHAT'S THE MATTER? YOU'VE NEVER SEEN A 6-FOOT POODLE?

NOW ALL I NEED IS SOME CHIPS...

Hot rod, sports car, dragster, Cadillac, low-rider  (Don't forget the fuzzy dice hanging off the mirror.)

**Cinderella**
>─┼─◈─┼─<

**Fairy Godmother**
>─┼─◈─┼─<

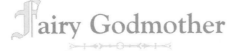

**The New Look**
>─┼─◈─┼─<

Add beautiful gown, glass slippers,
don't forget pumpkin coach.

# Bowling Night (Add bowling pins.)

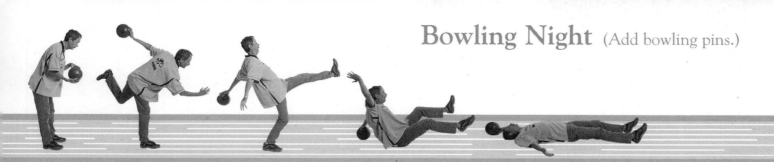

# Hanging Out the Clothes (Add clothes and line.)

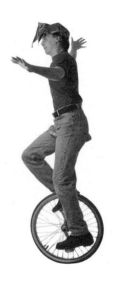

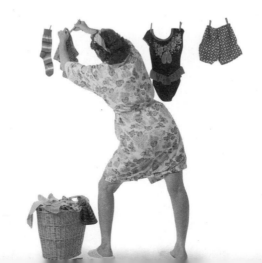

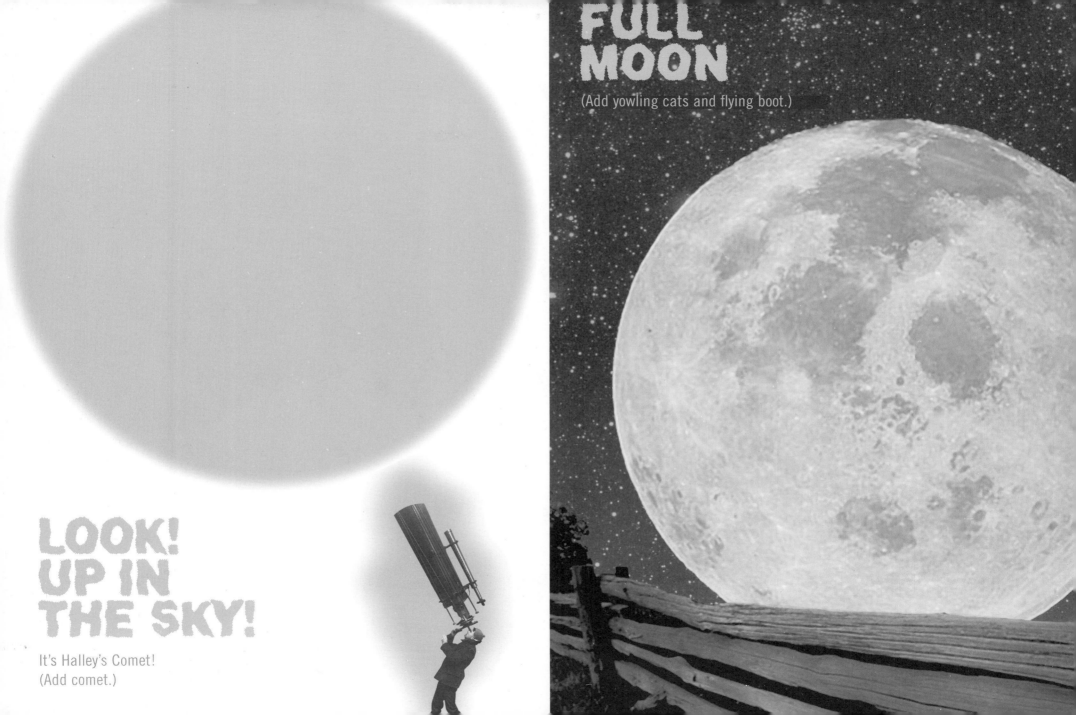

# LOOK! UP IN THE SKY!

It's Halley's Comet!
(Add comet.)

# FULL MOON

(Add yowling cats and flying boot.)

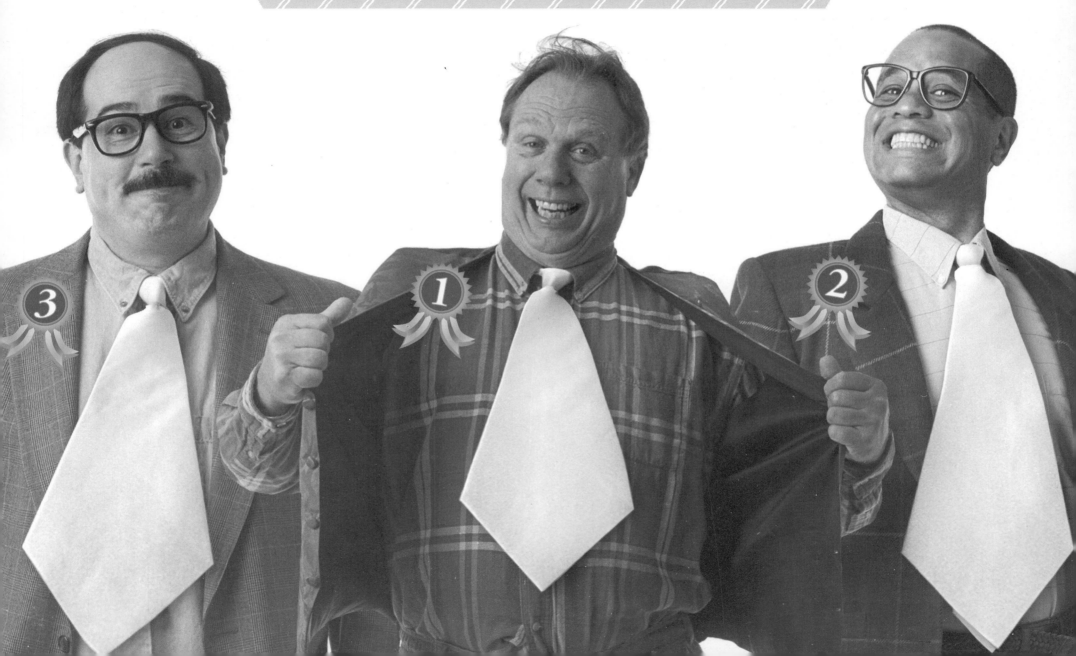

FINALISTS IN THE WORLD'S UGLIEST TIE CONTEST

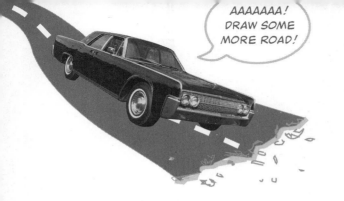

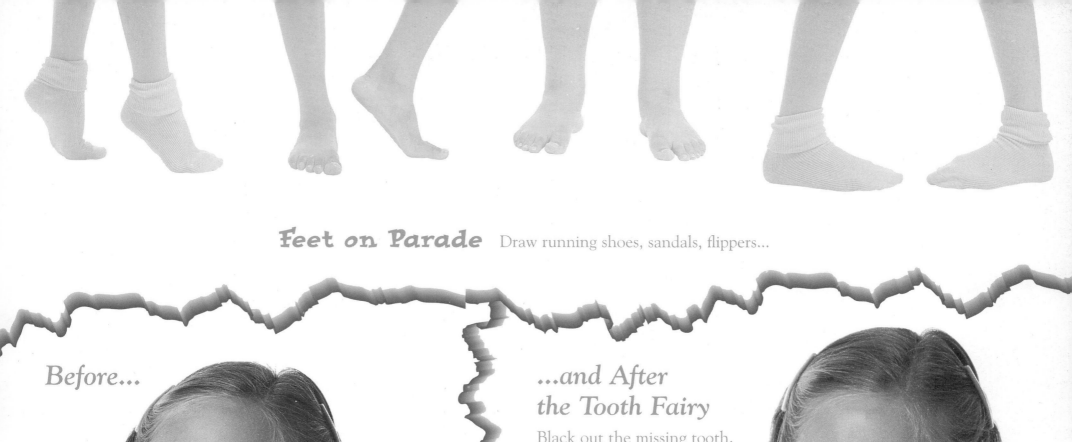

**Feet on Parade**  Draw running shoes, sandals, flippers...

*Before...*

*...and After the Tooth Fairy*

Black out the missing tooth.

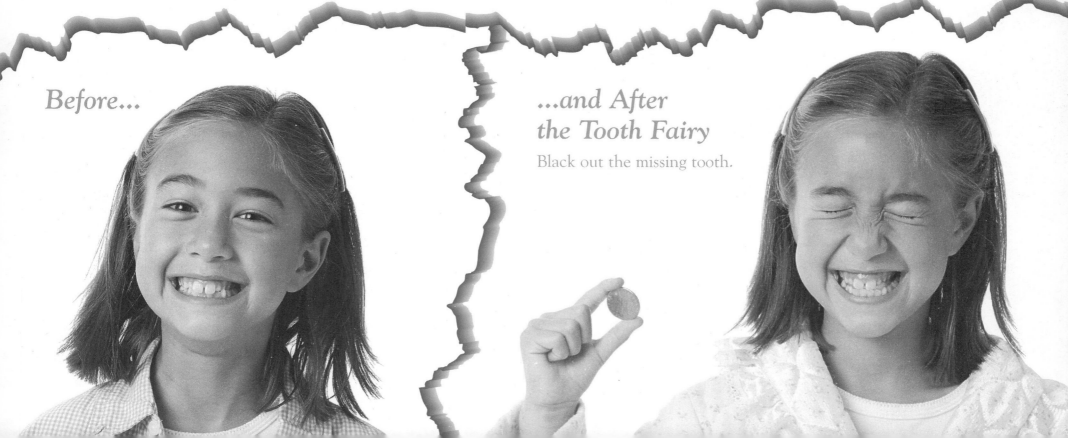

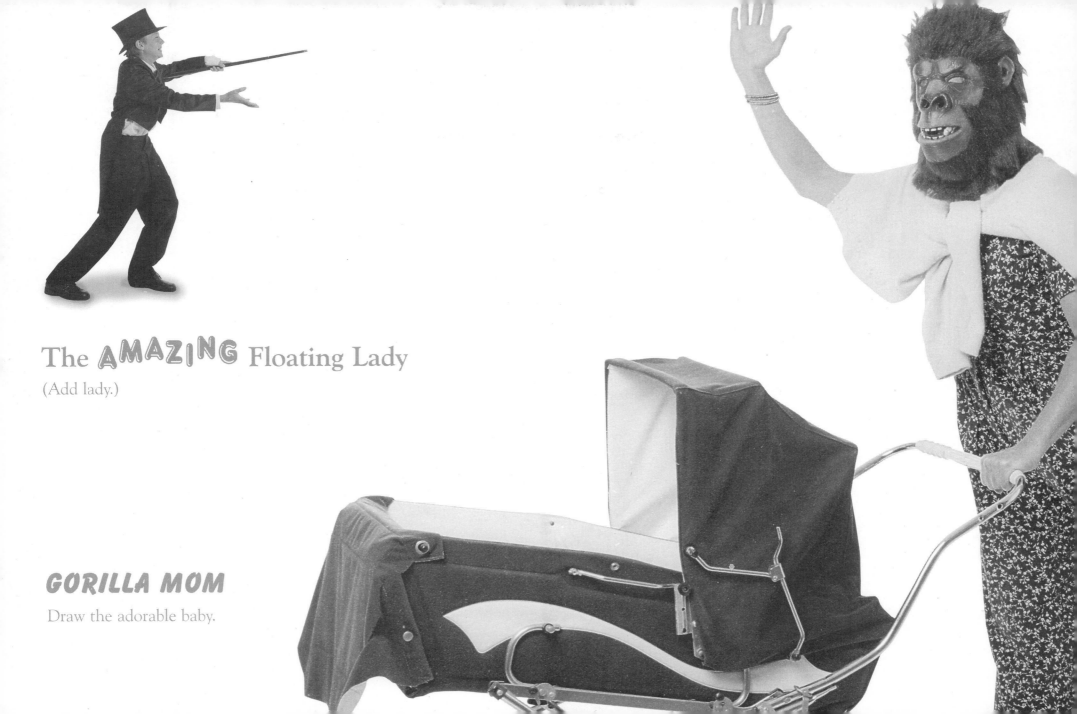

The **AMAZING** Floating Lady

(Add lady.)

## GORILLA MOM

Draw the adorable baby.

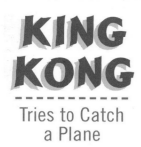

# KING KONG

Tries to Catch
a Plane

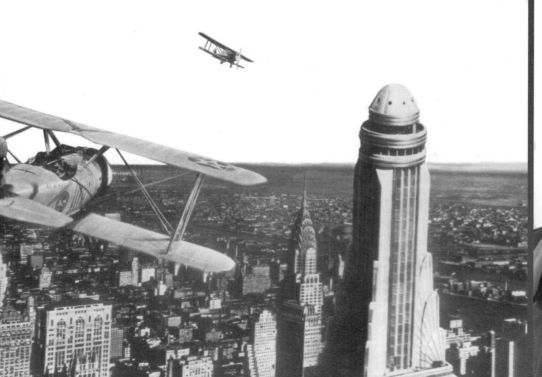

ATTACK FROM
OUTER SPACE

(Add flying saucers.)

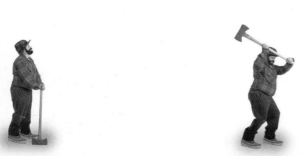
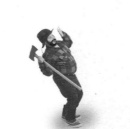
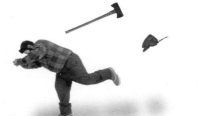

# WORLD CHAMPIONSHIP TUG-OF-WAR

*Four Humans Take On a...*

*Young Boy Trips, Accidentally Spills Water on Lady at Opera*

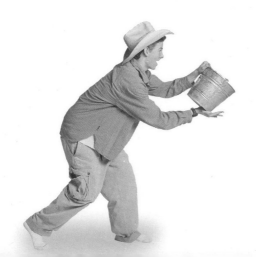

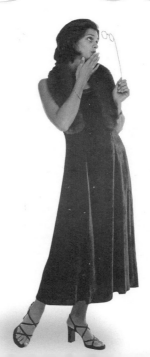

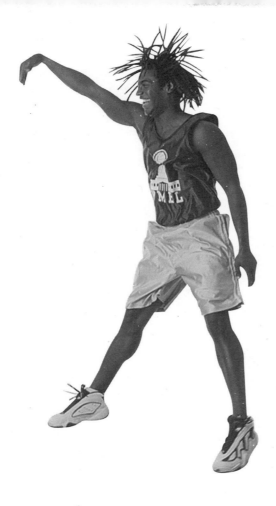

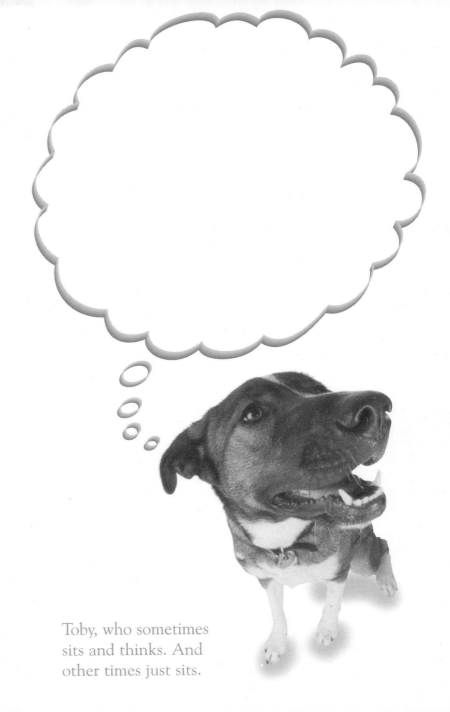

## Slam Dunk

(Add hoop and ball.)

Toby, who sometimes sits and thinks. And other times just sits.

# Man Swallows _____

## Surgeon successfully removes it.

(Anchor, hammer, frying pan, spatula, fork, screwdriver, saw, pitcher, microwave oven, shoe, basketball, stool...)

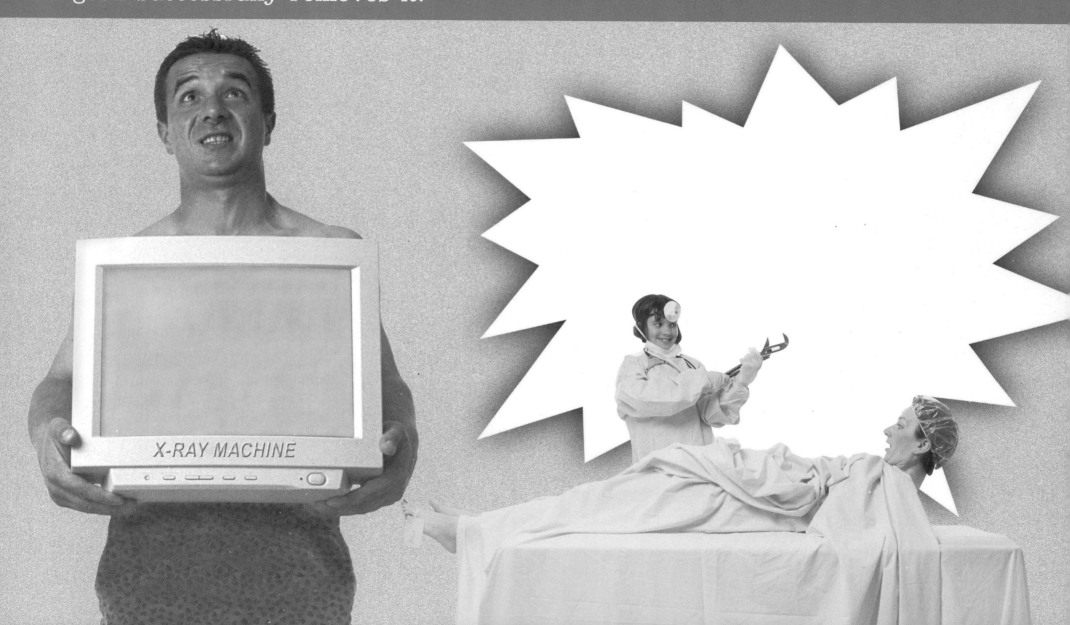

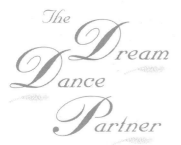

*The* *Dream*
*Dance*
*Partner*

(Mickey Mouse,
the guy next door,
Leonardo DiCaprio...)

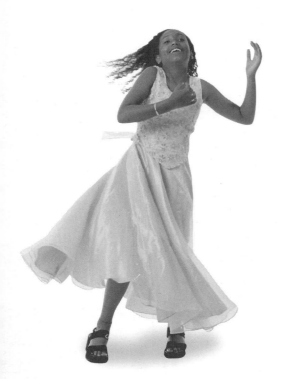

*Fancy Ring*
*&* *Fancy*
Earrings

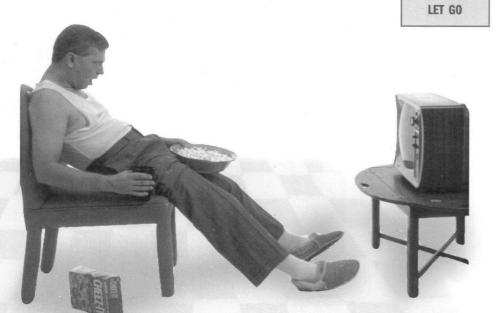

Add
springs.

**BLAST
OFF**

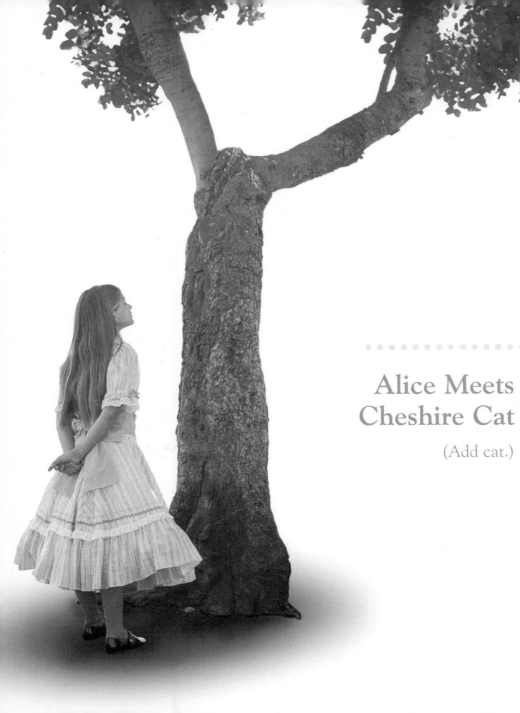

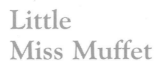

## Little Miss Muffet

Add spider.

## Alice Meets Cheshire Cat

(Add cat.)

## Jack Jumps Over the Candlestick...

or lightbulb, flashlight, Coleman lantern, highway flare, lava lamp...

Do not let this page
remain blank

*Your job?* Add mustaches, black eyes, stitches, fangs, beards, glasses...

**Q:** *What Did the Mommy Giant Give the Baby Giant When the Little Tyke Wasn't Feeling Well?*

**A:**

*(Add baby giant.)*

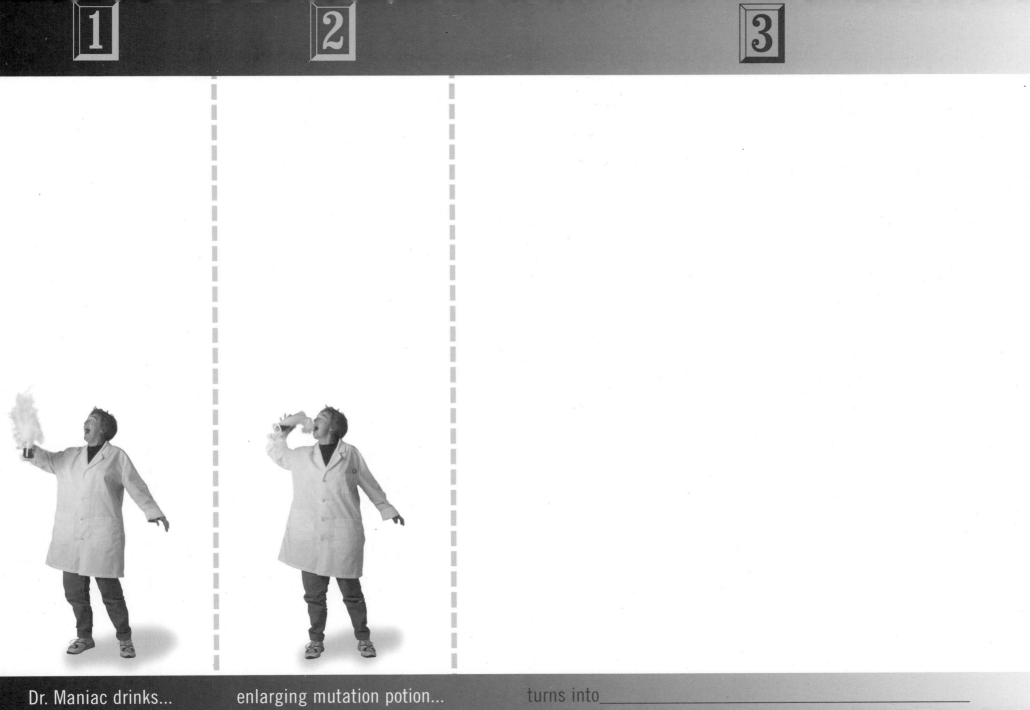

Dr. Maniac drinks...    enlarging mutation potion...    turns into_____

A Hair-Dried Human Cannonball

Land O'
# GIANTS II

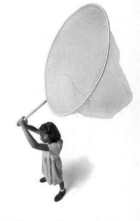

Lisa Captures Rare, Endangered Mega-Butterfly
*(Add butterfly.)*

How Do You Spell Fear? "H..A..M..S..T..E..R."

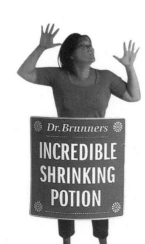

HELP! I'M TRAPPED INSIDE A BOTTLE!

Dr. Brunners
**INCREDIBLE SHRINKING POTION**

*(Draw bottle.)*

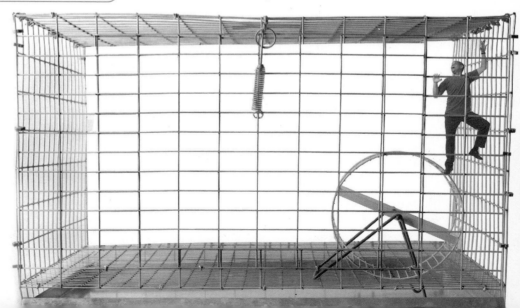

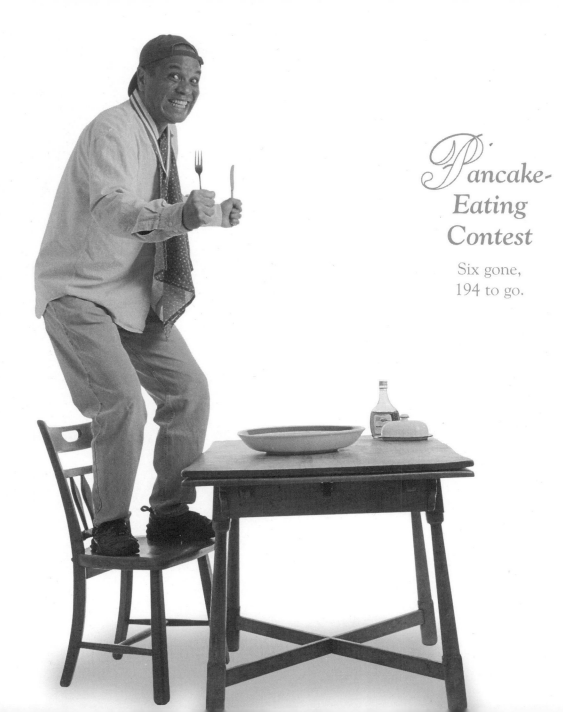

*P*ancake-
Eating
Contest

Six gone,
194 to go.

OUCH!

 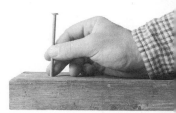

*BANG!*
(Add hammer.)

 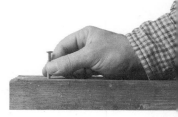

*BANG!*
(Add hammer.)

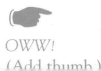 

*OWW!*
(Add thumb.)

Josh of
Arabia Atop
His Sturdy
Dromedary,
Clyde

Michael the
Daredevil
Sticks Head
in Lion's
Mouth

*(Add camel.)*

*(Add lion.)*

Rabbit Tamer

Rhino Tamer

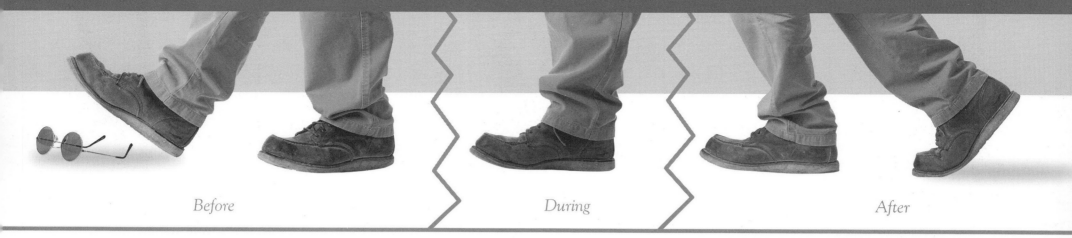

Before

During

After

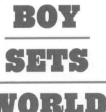

# 2
## GIRLS
## CARRYING

piano, couch, very large shoe,
world record–setting
birthday cake, boulder, safe...

## BOY
## SETS
## WORLD
## RECORD:

202 Books on Head

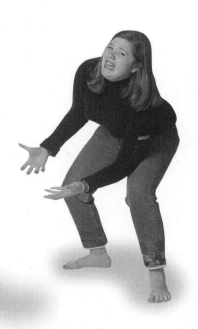

MAN     PHOTOGRAPHING     RUNAWAY     TRAIN
(no brakes, no engineer)

# The
# Burning
# Building

Firewoman Laurie
is on the job.

# The
# Diving
# Board

Add pool and
diving board.

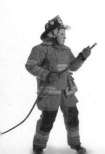

# Witch & Cauldron

(Add cauldron full of nasty stuff.)

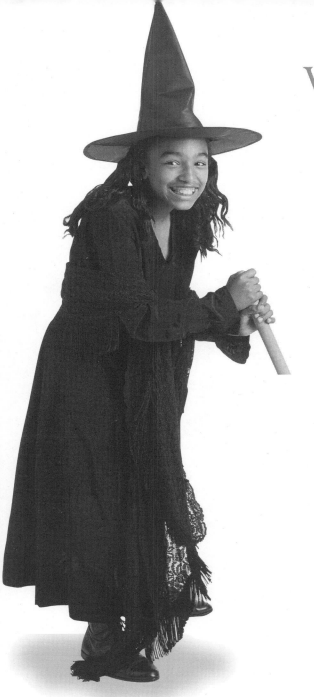

First Prize Winner in Kite Contest

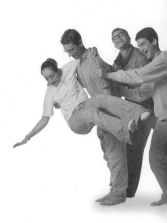

Bad Guys
Attempt to
Drop Innocent
Maiden Off
Cliff

*(Add cliff.)*

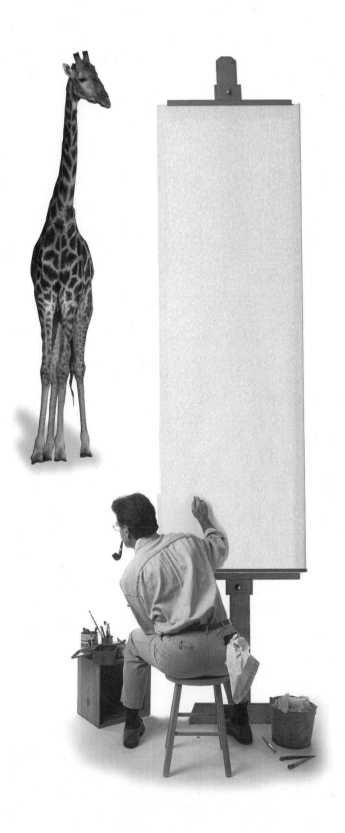

Norman Adds Finishing
Touches to His Stunning
Giraffe Portrait

Our
Hero
Awaits

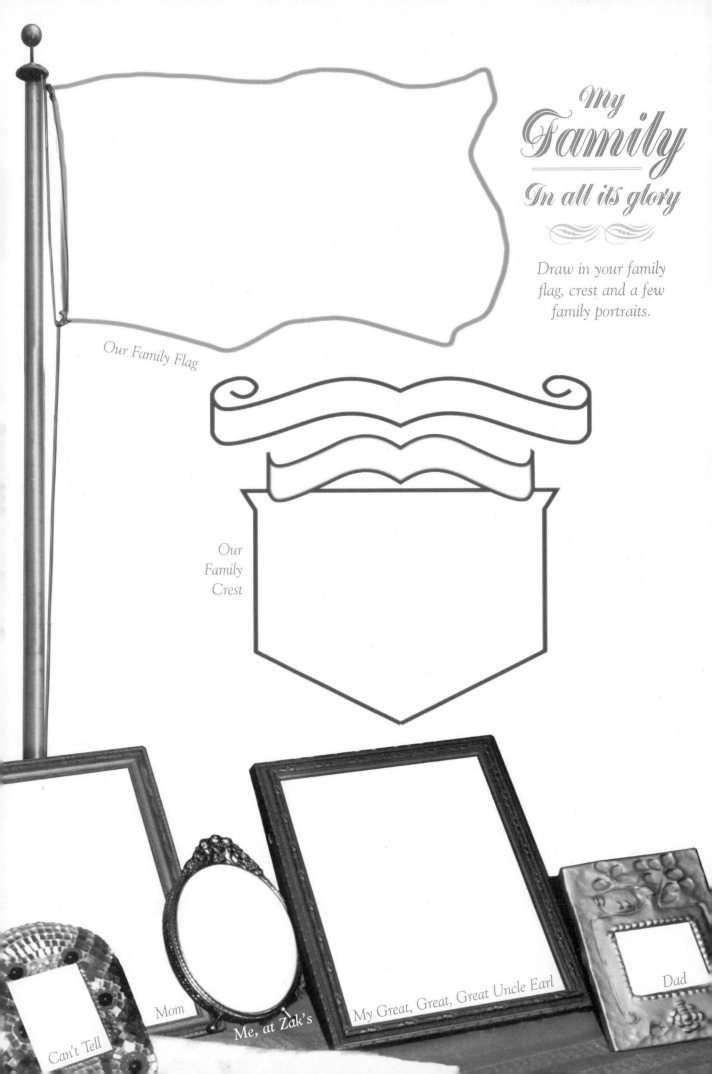

*My*
## *Family*
*In all its glory*

Draw in your family flag, crest and a few family portraits.

*Our Family Flag*

*Our Family Crest*

Can't Tell

Mom

Me, at Zak's

My Great, Great, Great Uncle Earl

Dad

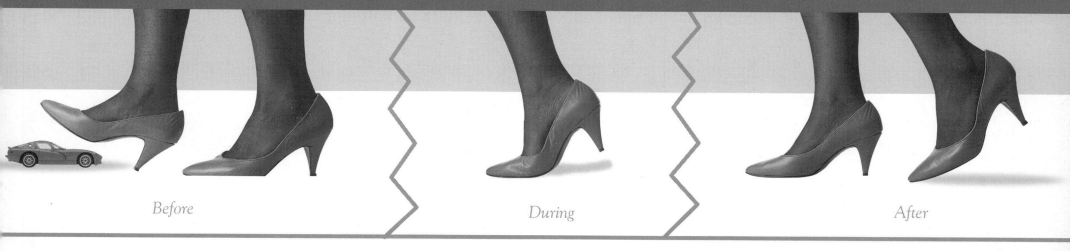

*Before*

*During*

*After*

## Channel Surfing

(Add TV.)

DO NOT ALLOW THIS SPACE TO REMAIN BLANK.

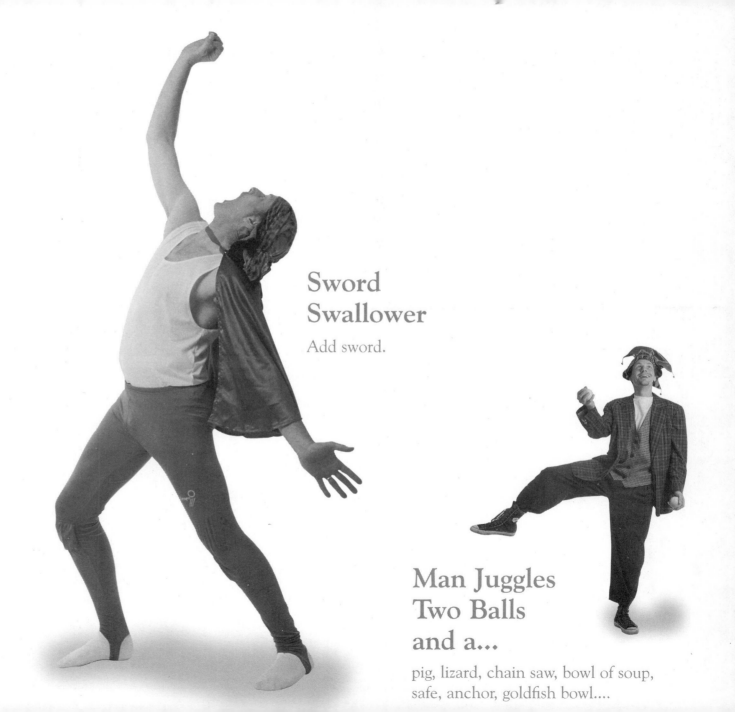

## Sword
## Swallower

Add sword.

## Man Juggles
## Two Balls
## and a...

pig, lizard, chain saw, bowl of soup,
safe, anchor, goldfish bowl....

## HEAVENS! It's a...

bird pooping, safe falling, piano plung-
ing, feather floating, huge raindrop...

# LOCH NESS MONSTER

AIEEE! IT'S A FULMINATING RHINOBLASTER!

# Sir Giddyup & the Dragon

## OLÉ OLÉ!
### The Bull Approaches

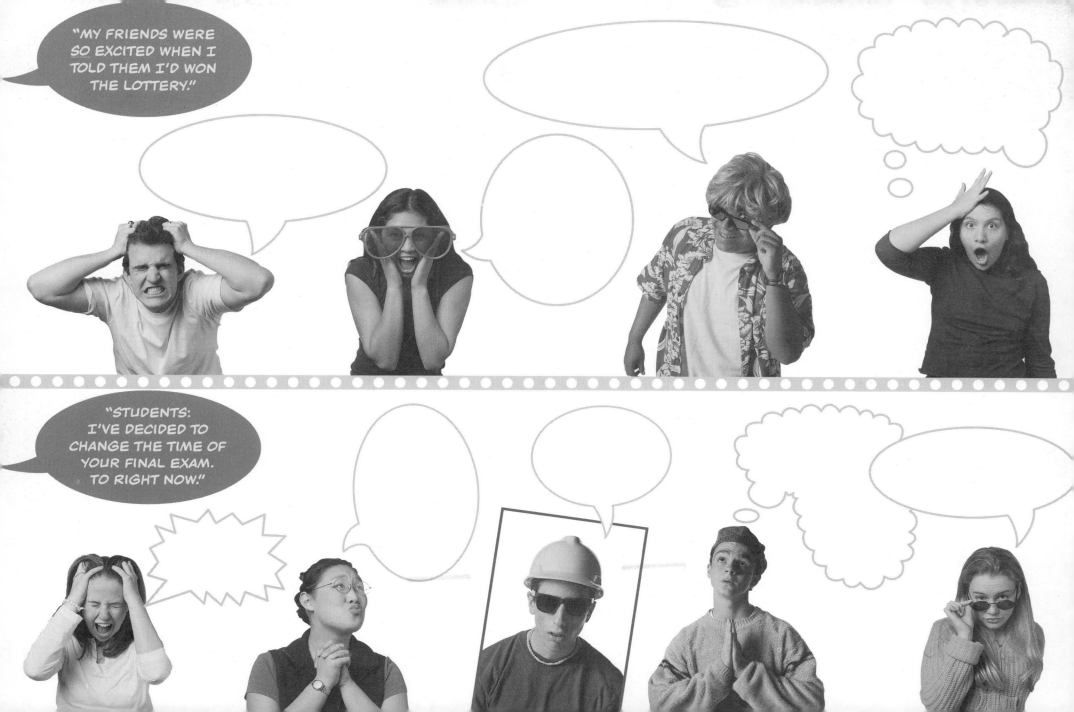

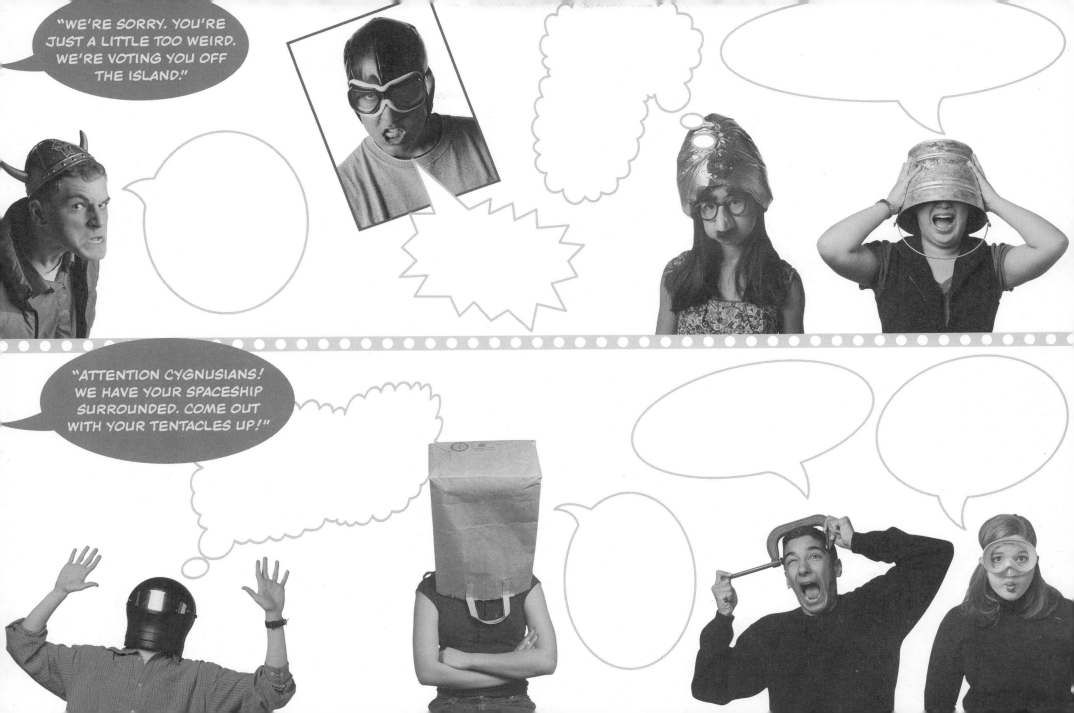

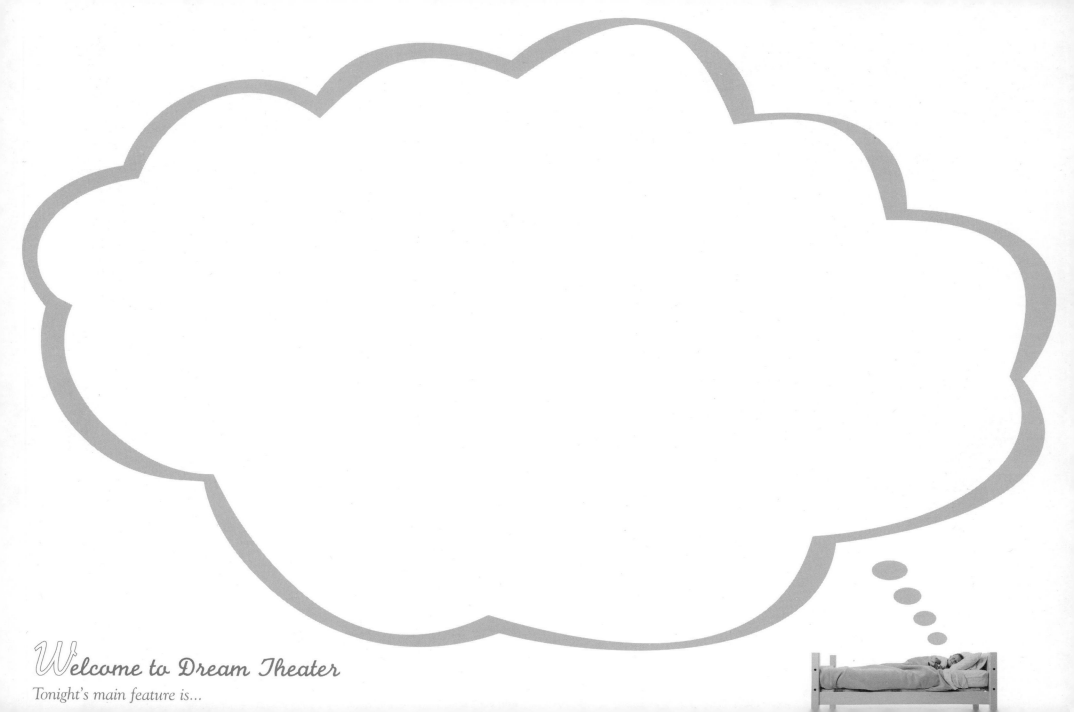

Welcome to Dream Theater

Tonight's main feature is…

## Man Steps into Open Manhole

or banana peel, dog poo, thumbtack, sleeping dog, rollerblade...

DRAW A PAIR OF
*Million Dollar Shoes*

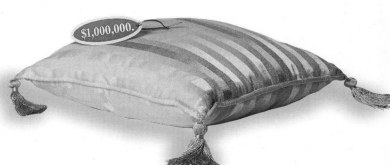

$1,000,000.

# CRAZY EDDIE'S USED CARS

## *(Add Today's Special!)*

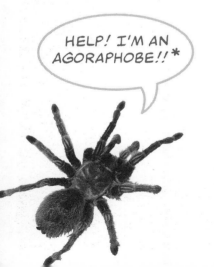

HELP! I'M AN AGORAPHOBE!!*

*AǴ/O/RA/PHOBE: TERRIFIED OF BLANK, EMPTY SPACES.

# Jack, Jill & Their Hill

(Add hill. Don't forget flying bucket and well.)

# Aladdin Meets the Genie

(Add genie.)

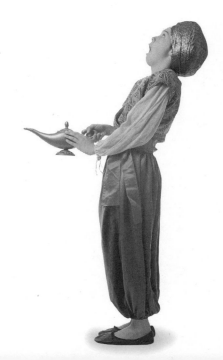

# The Cat-Under-the-Bed Problem
(Add cat. Add bed.)

# Horse-in-Boots
(Add horse.)

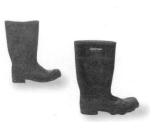
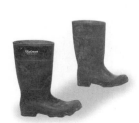

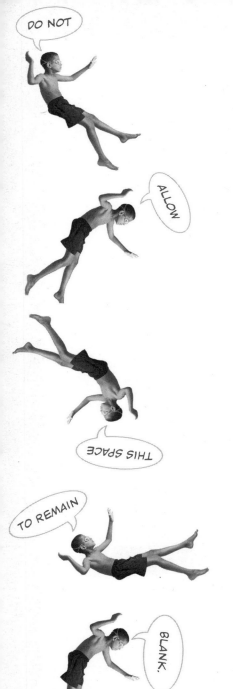

# What Do You Get When You Cross A...

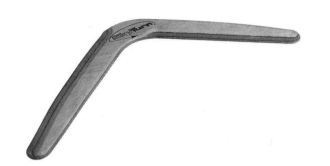 

... **B**oomerang with a **B**owling Ball **?**

 A **B**oomerball **!**

# What Do You Get When You Cross A...

... **B**aseball with a **P**orcupine **?**

 A **P**orcuball **!**

# BRONCO BUSTING

(Add bronco.)

Boy Plays with
Pet Boa Constrictor
(or vice versa)

Draw boat, waves and jump.

IT'S SUMMER

The ants take away the picnic. (Add ants.)

# Snake Charmer

(Add snake.)

The
# AMAZING ALYSONINI

*Pulls Rabbit, Cat, Sink, Snake or Whatever Out of Hat*

## Ulysses on This End...

*Little Lisa, Chicken Little, Stuart Little, Tweety Bird, Alvin Chipmunk, Tom Thumb, Tinkerbelle or Mighty Mouse on this end.*

Ian, World Champion
**BUBBLE BLOWER,**
Goes for the Gold.

# Aladdin's
## Magic Carpet
*(Add Aladdin.)*

**Fun House Mirror** Draw a wobbly self-portrait.

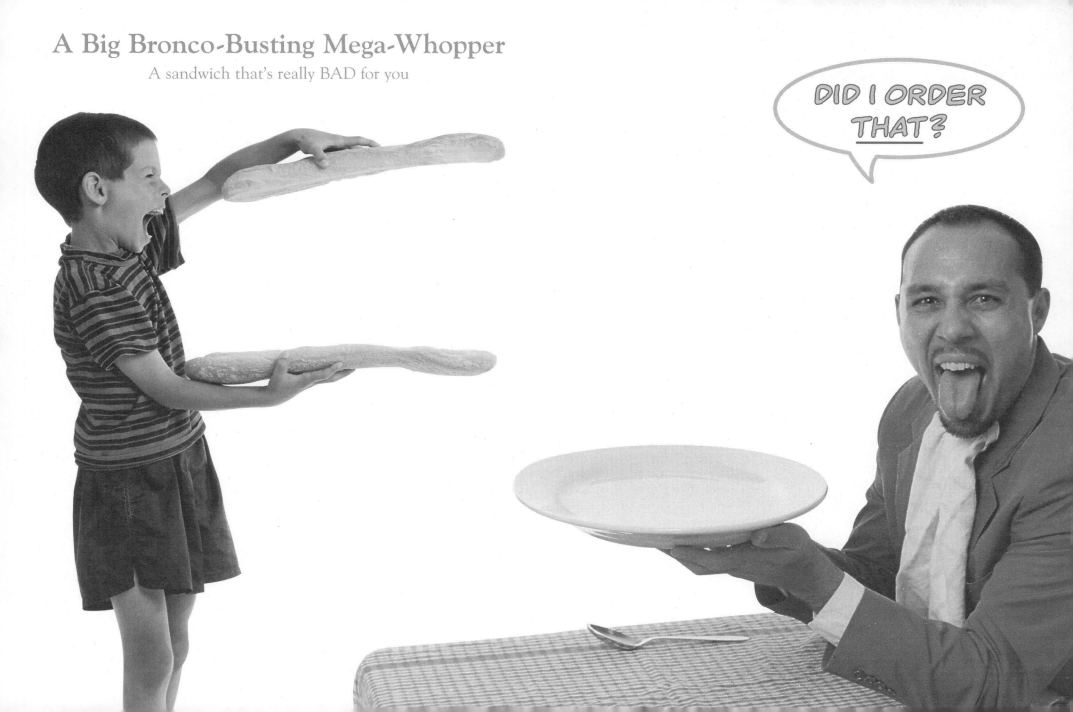

The Page of

**A**

The Page of

The Page of

C

_he _uic_

T Q K

br___ ____ OX

O W N F

___ um __ __

J P S

OV___ __ ___ THE

E R T HE

LA_Y

Z

__ __ __

D O G

QUICK BROWN FOX GOES HERE

# Credits

**Our Human Models:** Emika Abe • Adlai Alexander • Jocelyn Alexander • Rachel Arnow • Maureen Bard • Shanna Barker • Christina Belen • Andrea Benitez • Scott Benitez • Harriet Benson • Mira Bertsch • Raizin Bob-Waksberg • Leyla Boissonnade • Joseph Brady • Willie Branch • Elizabeth Buchanan • Nick Burr • Gabi Cahill • Grace Cahill • Laurie Campbell • John Cassidy • Gilbert Chu • Larkin Clark • Ken Constantino • Christina Conte • Beth Crisafi • Bob Cullenbine • Kelly Curran • Adam de Monet • Matt Devine • Dave Dickinson • Alicia Edelman • Chris Felde • Rob Ferris • Sarah Flamm • Brian Flaxman • Jenner Fox • Kaela Fox • Peter Fox • Philip Fox • Susan Fox • Adam Furlong • Daniel Furlong • Kara Furlong • Nick Godin • Seth Golub • Sarah Griner • Alec Guthrie • Mark Hanson • Briggs Hatton • Blake Holland • Sean Hurlbert • Annushka Iyengar • Chelsea Jennings • Tessa Joncas • Callie Joncas • Jenny Judson • Jane Kaiser • Chieko Kakihana • Haris Karadjuzovic • Ian Patrick Kelly • Carolyn Kemp • Eve Knowles • Khyri Knowles • Connie Kuge • Matt Lattanzi • Michael Leen • Jurgen Lew • Ryan Lillis • Grace Liu • Jenna Losé • Gardner Loulan • Mary Sunshine Luna • Gary Mcdonald • Brian McGilloway • Maria Patricia Miranda • Ryan Moin • E. Ullysses Morales • Paulina Morales • Paul Newman • Jaklyn Nye • Luisa Nye • Rebekah Nye • Bill Olson • Vanessa Pan • Olivia Perez-O'Dess • Travis Perkins • Neil Phillips • Molly Riley • Laura Rose • Meg Ross • Karen Salveson • Jim Sanchez • Josh Schneck • Tiffanie Annette Scott • Maria Seamans • Alyson Seedman • Caitlin Shirts • Tyler Simonds • Altan Sun • Heidi Swartz • Swen Swenson-Graham • Brittany Taylor • Cass Taylor • Chantal Taylor • Amna Tokmo • Sulejman Tokmo • Eric Tracy-Cohen • Jill Turney • Liam Twomey • Ying Vallone • Clark Vineyard • Leslie Vineyard • Nelson Vineyard • Kathy Wang • Claude "Bud" Weaver • Scott Williams • Andrew Willis-Woodward • Shantae Wright • Owen Wyatt • Jordan Zenger

FILL IN THE BUTTERFLY WITH YOUR OWN DESIGN,

DID YOU KNOW THAT SOME VERY TALENTED ELEPHANTS CAN DRAW?

**Our Animal Friends:** Earl Grey (the distinguished Cat) • Sammi the Dog • Gretle B. Thompson (the Dog)

**PRINCIPAL MODEL PHOTOGRAPHY:** Peter Fox • **Model Wranglers:** Susan Fox, Corie Thompson • **STOCK PHOTOGRAPHY— Corbis:** p. 2 (zebra) © Charles O'Rear/Corbis; p. 16 (Mt. Rushmore) © Joseph Sohm, ChromoSohm, Inc./Corbis • **Photodisc:** p. 7 (snake, spider, lion, and rhino); p. 9 (frame), p. 12 (leopard); p. 13 (skunk); p. 20 (clown shoes); p. 28 (bulldog); p.70 (TV console); p. 71 (spider); p. 75 (porcupine); p. 82 (alligator and reindeer); p. 83 (bananas, bunnies, beetle and boot); p. 84 (cow and alarm clock); p. 86 (elephant); p. 87 (cow and camel); p. 88 (horse and llama) • **Photo Researchers:** p. 60 (giraffe) © M.Phillip Kahl/Photo Researchers, Inc. • **Animals, Animals:** p. 13 (moose) © Brian Milne/Animals Animals; p. 84 (fluffy chicken) © Robert Dowling/Animals Animals; (falling cat) © Gerard Lacz/Animals Animals • **Artville:** p. 35 (car) Carltons/Artville; p. 75 (bowling ball and baseball) Radlund & Associates/Artville; p. 82 (artichoke) Jeff Burke & Lorraine Triolo/Artville; p. 86 (butterfly) Burke/Triolo/Artville • **Photofest:** p. 8 (witch); p. 47 (movie stars) • **Turner:** p. 38 (King Kong) courtesy of Turner Entertainment Company • **Photo of Cat:** p. 29 Richard Reader • **Photo Research:** Stephen Forsling • **Permissions:** Mary Beth Arago

**Broken Drawers:** John Cassidy, Cassandra Barney, Michael Sherman, Elizabeth Buchanan, Carla Jimison, Paul Weed, Laurie Campbell, Caitlin Shirts

**Design:** Elizabeth Buchanan • **Cover Illustration:** Vitali Konstantinov • **Cover Coiffure:** Caitlin Shirts • **Graphic Production and Illustration:** Elizabeth Buchanan, Teresa Roberts, Natalie Hill • **Photoshop Dude:** David Barker

Thank you to all our wonderful testers and to the Gunn High School and Sacred Heart Preparatory Drama Classes.

...tz certified books and a diverse collection of ...rom The Klutz Catalog. It is, in all modesty, unlike any other ...s yours for the asking.

## Who are you?

Name: _____ Age: _____ ❑ Too high to count ⭘ Boy ⭘ Girl

Address: _____

City: _____ State: _____ Zip: _____

## My Bright Ideas!

Tell us what you think of this book: _____
_____

What would you like us to write a book about? _____
_____

❑ Check this box if you want us to send you The Klutz Catalog.

If you're a grown-up who'd like to hear about new Klutz stuff, give us your e-mail address and we'll stay in touch.

E-mail address: _____

👉 **KLUTZ**.com

Drawbreakers

HEY! WHERE'S MY DRIVER?

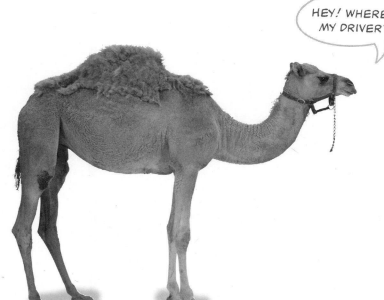

# More Great Books from Klutz

A Book of Artrageous Projects
The Amazing Book-a-ma-Thing for the Backseat
The Adventures of Joe Bender: Bendable Wire Hero
Drawing for the Artistically Undiscovered
Draw the Marvel Comics Super Heroes
A Super-Sneaky Maze Book
Painted Rocks
The Shrinky Dinks Book
The Most Incredible Sticker Book You've Ever Seen
Kids Travel: A Backseat Survival Kit
Watercolor for the Artistically Undiscovered

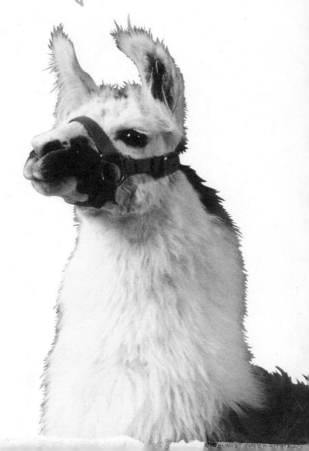

First
Class
Postage
Here

**KLUTZ**®
455 Portage Avenue
Palo Alto, CA 94306